New Beginnings

An Inspirational Adult Coloring Book

illustrated by Rebecca Purifoy

trust IN THE LORD.

Proverbs 3:5

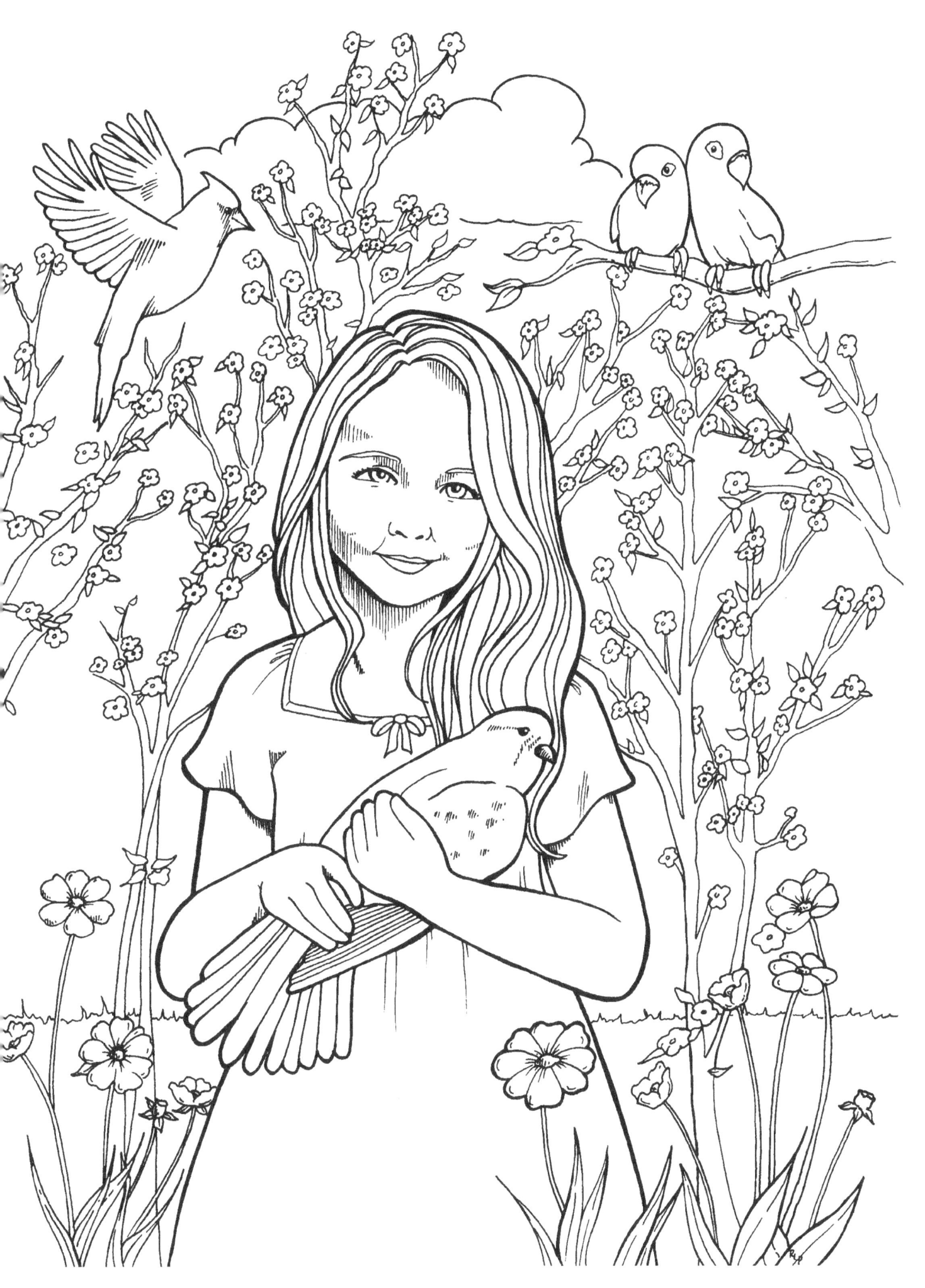

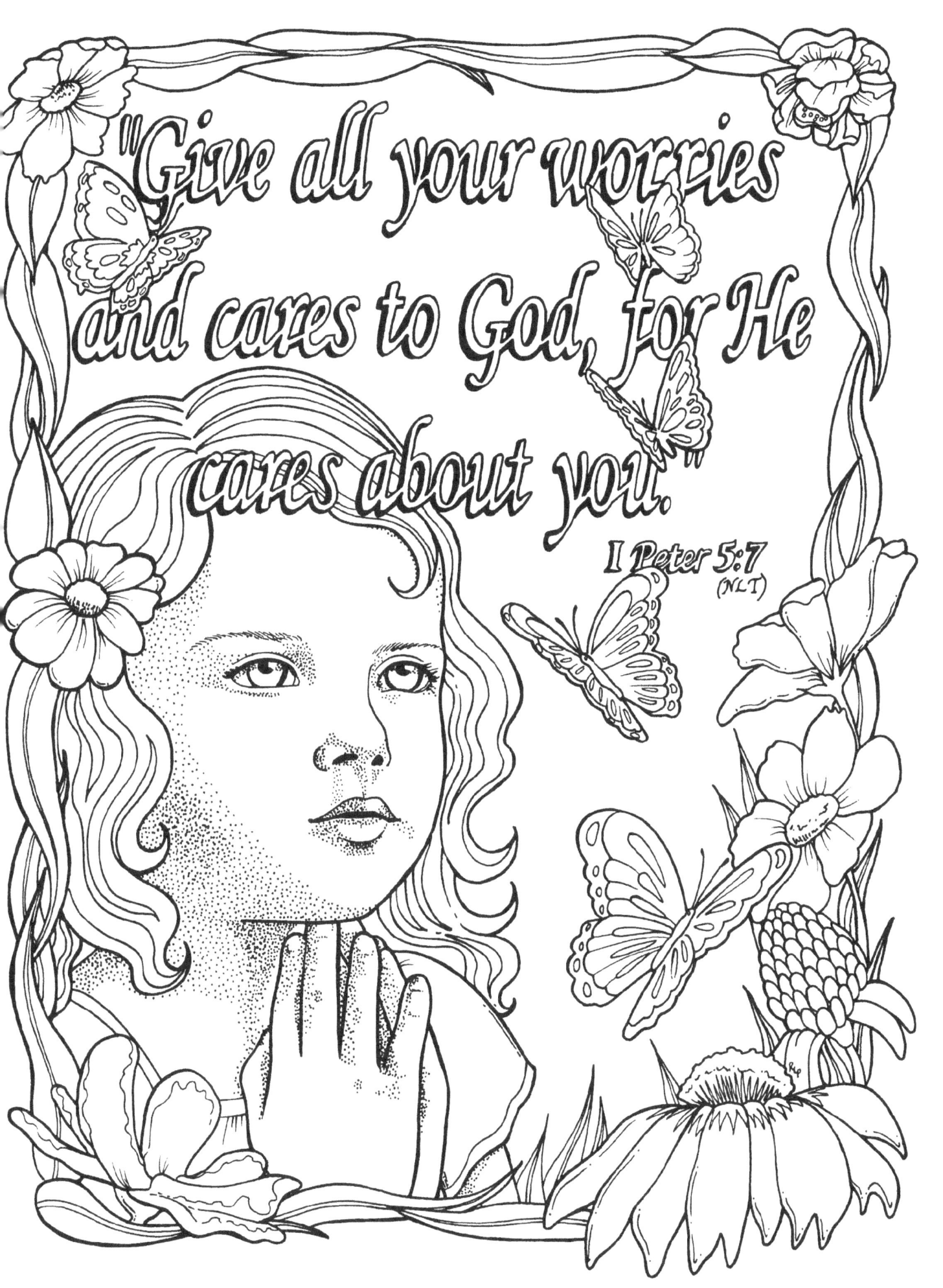

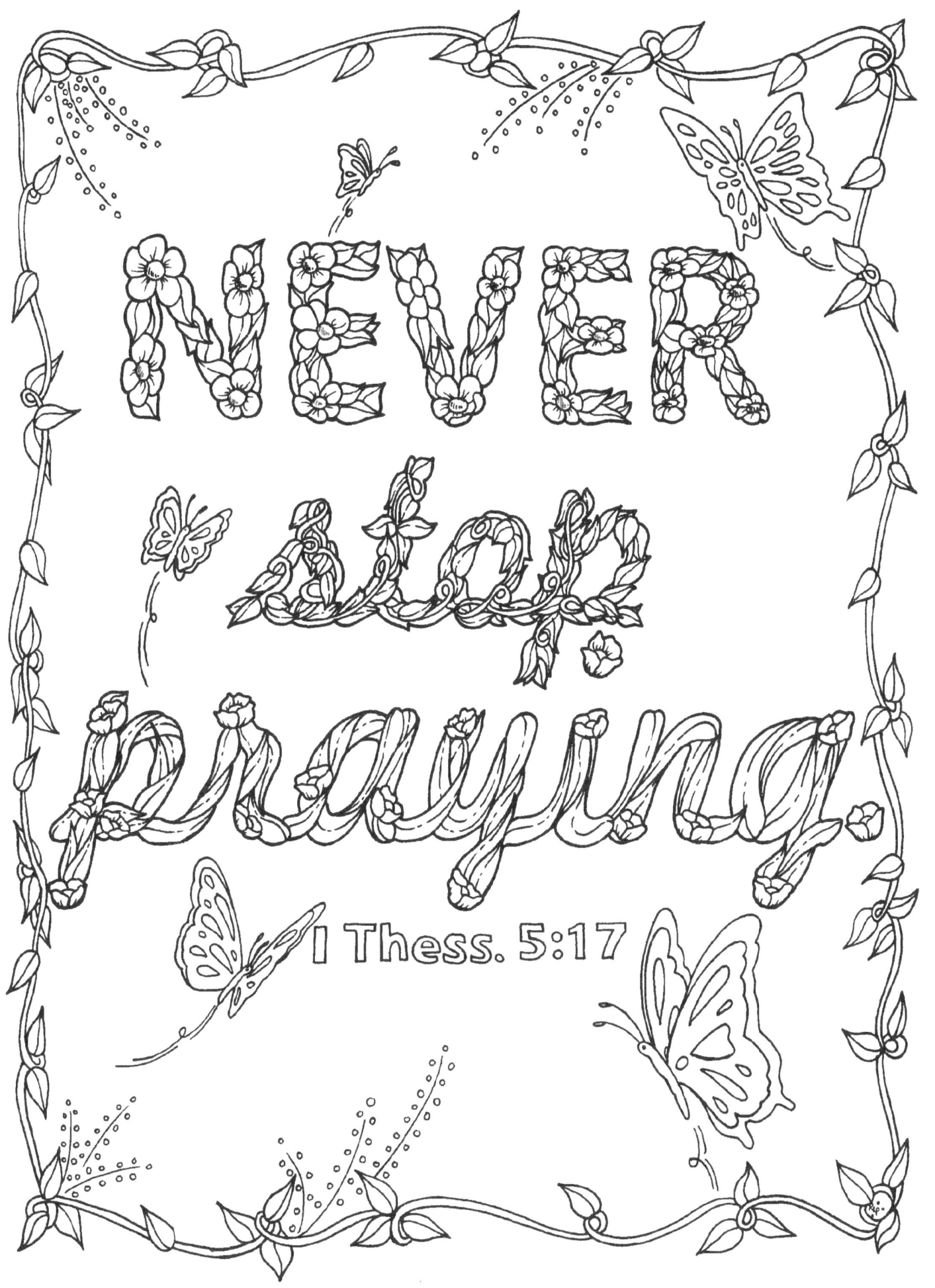

NEVER stop praying

I Thess. 5:17

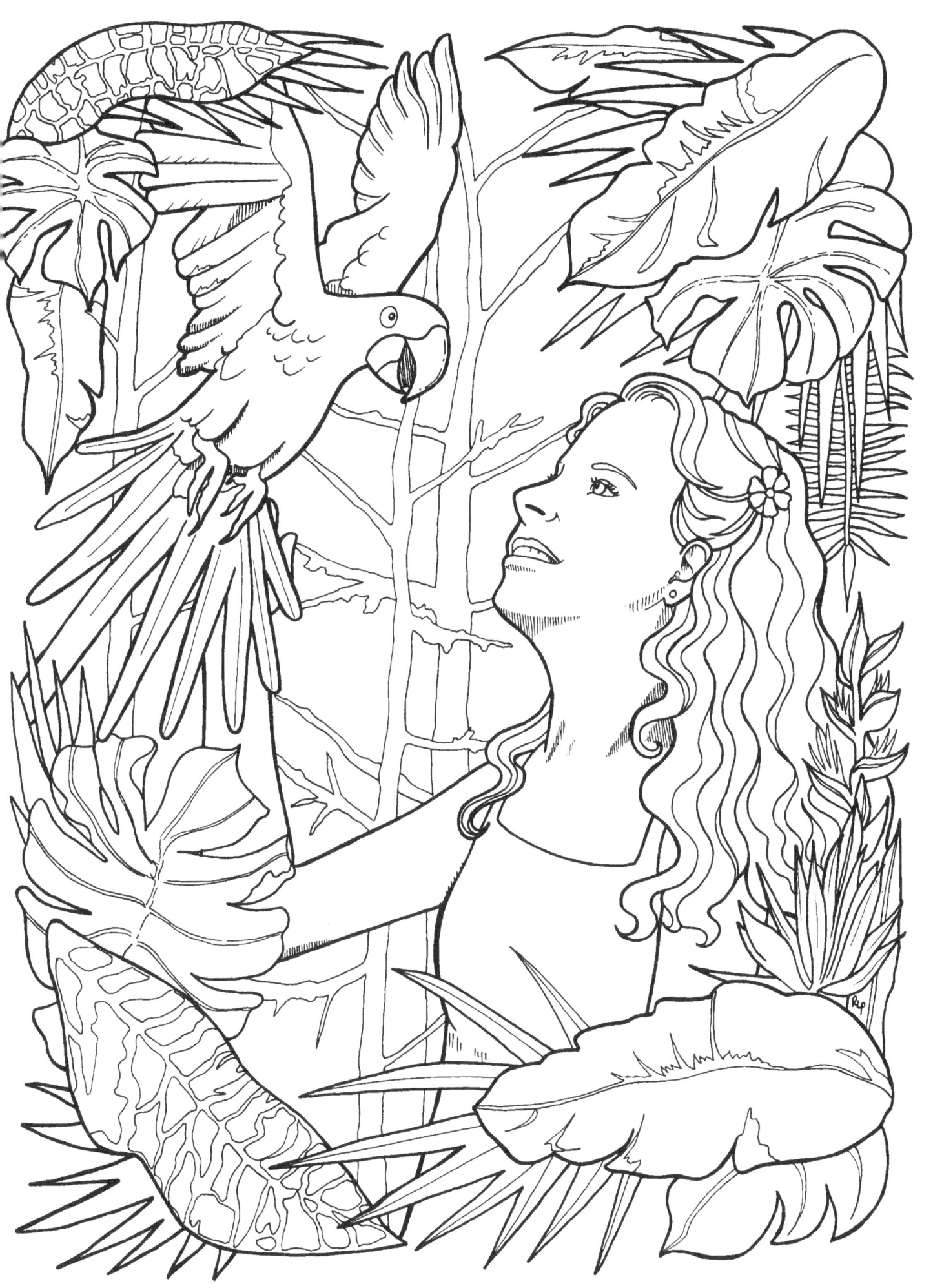

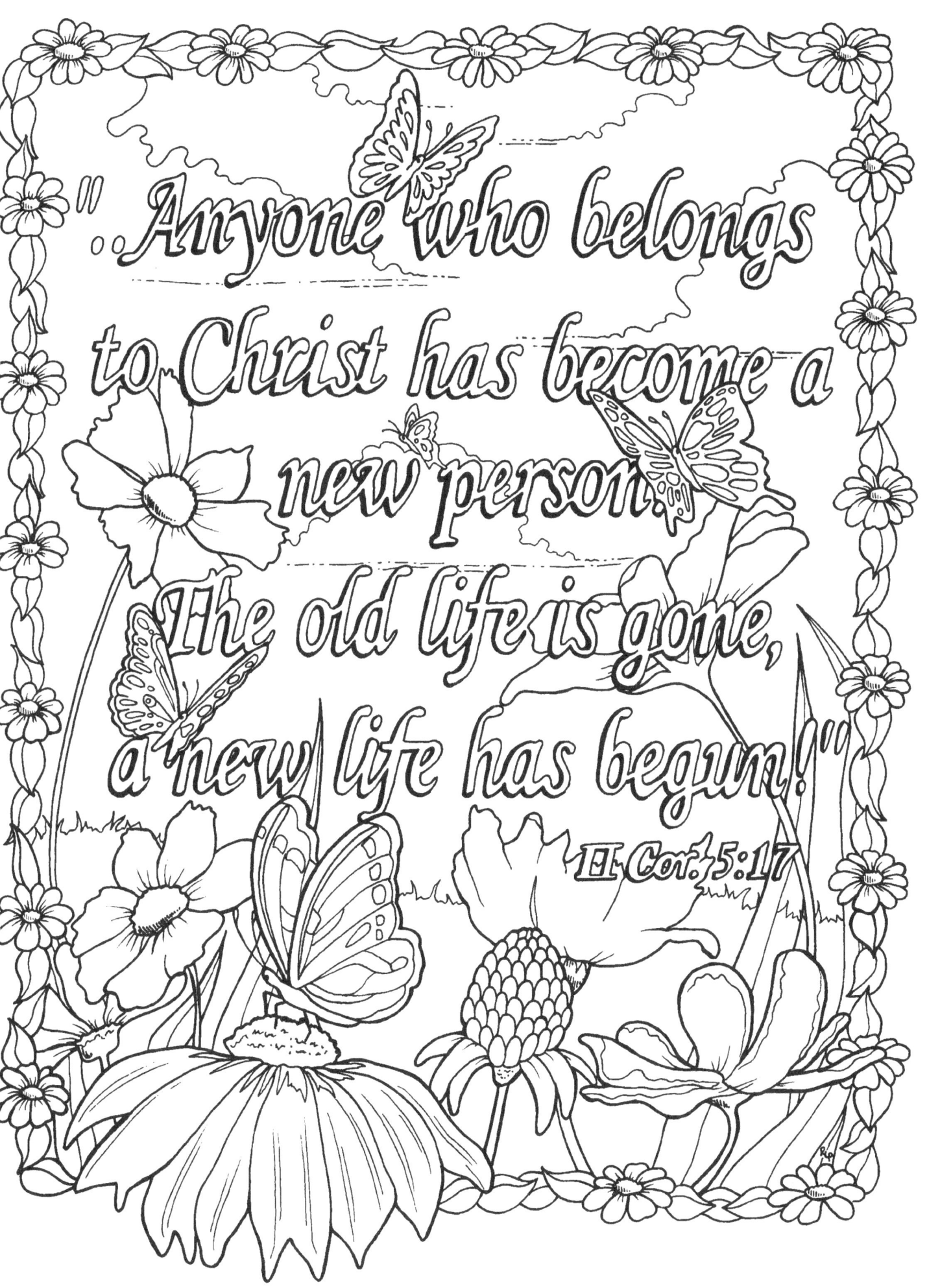

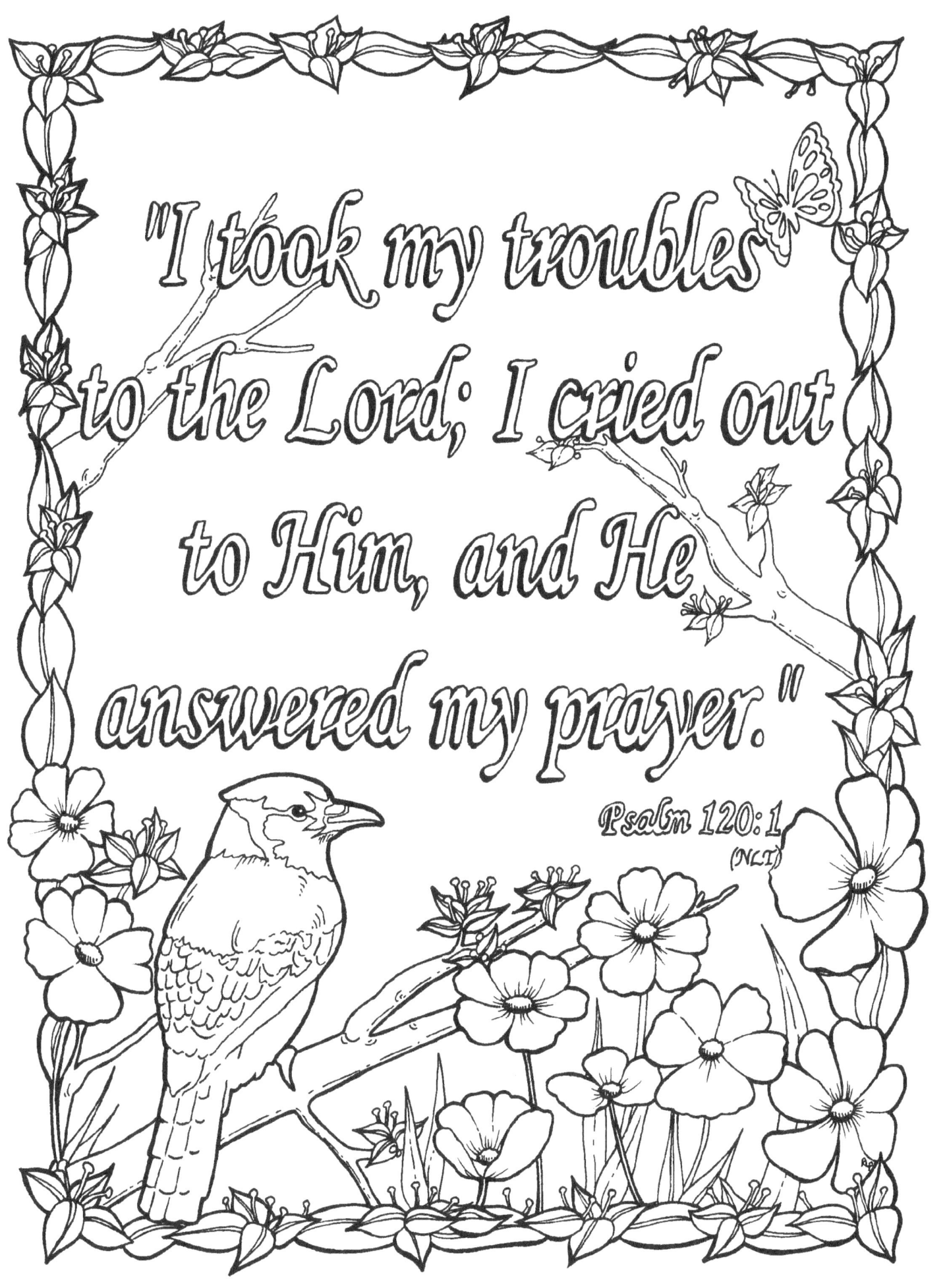

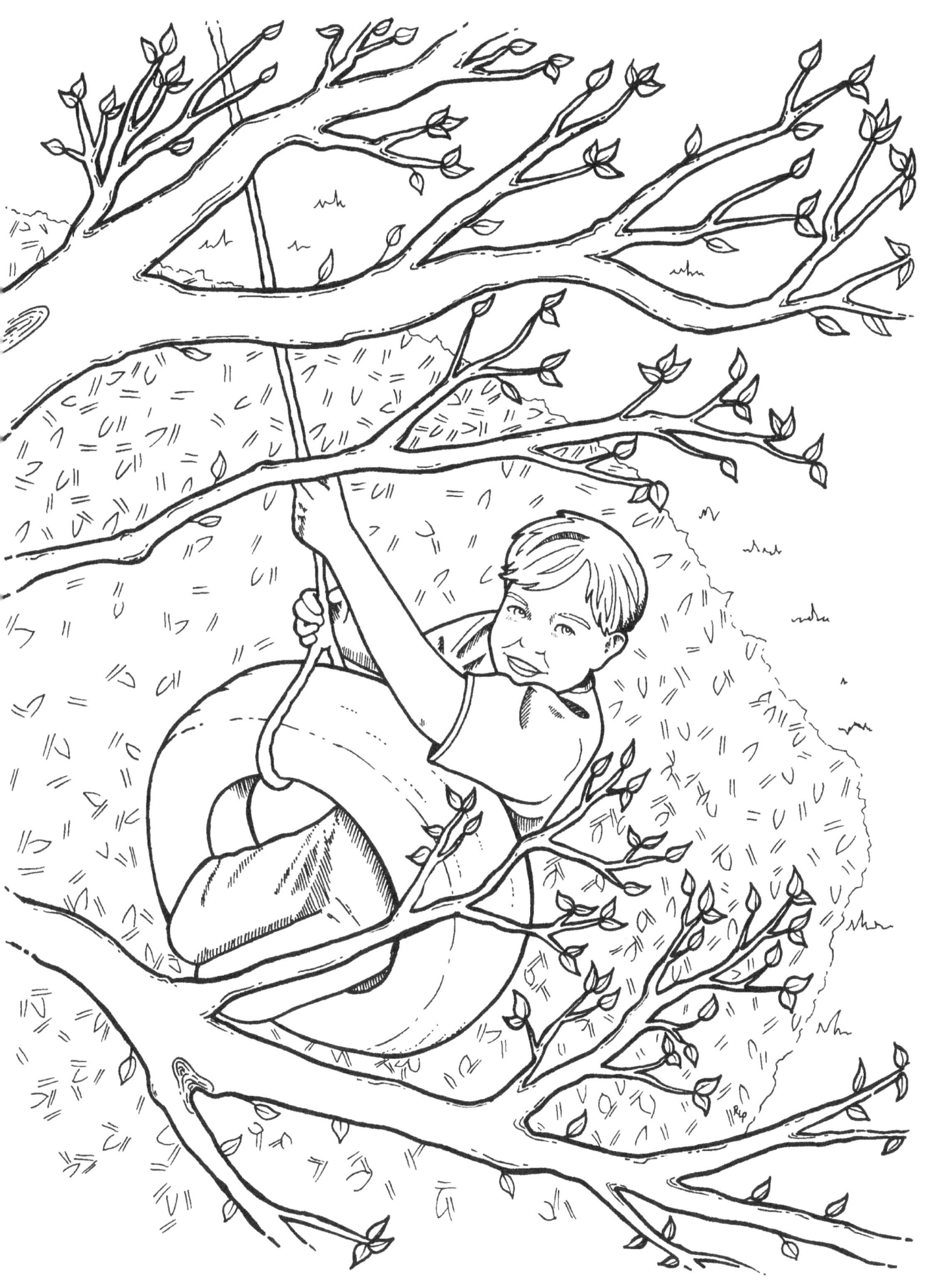

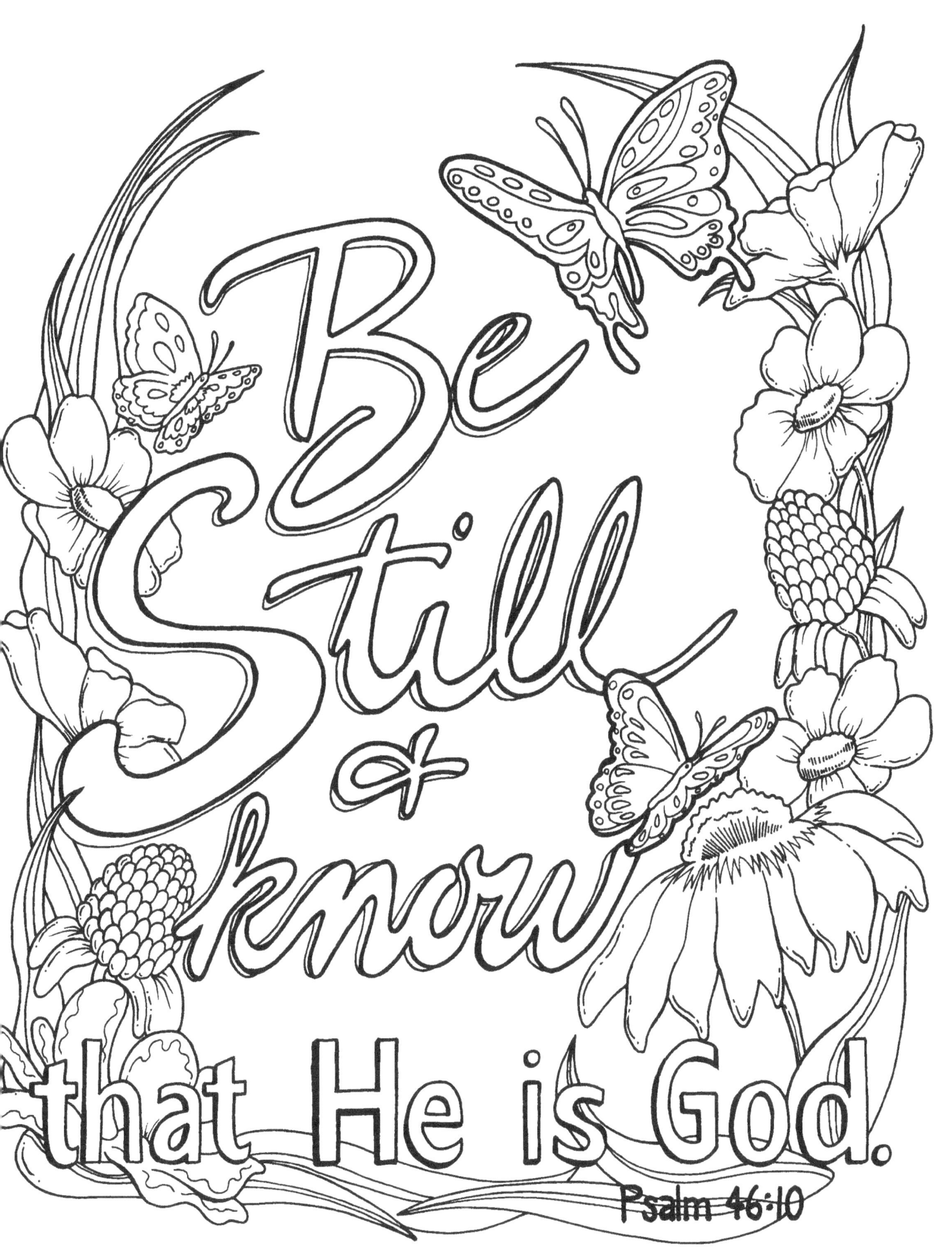

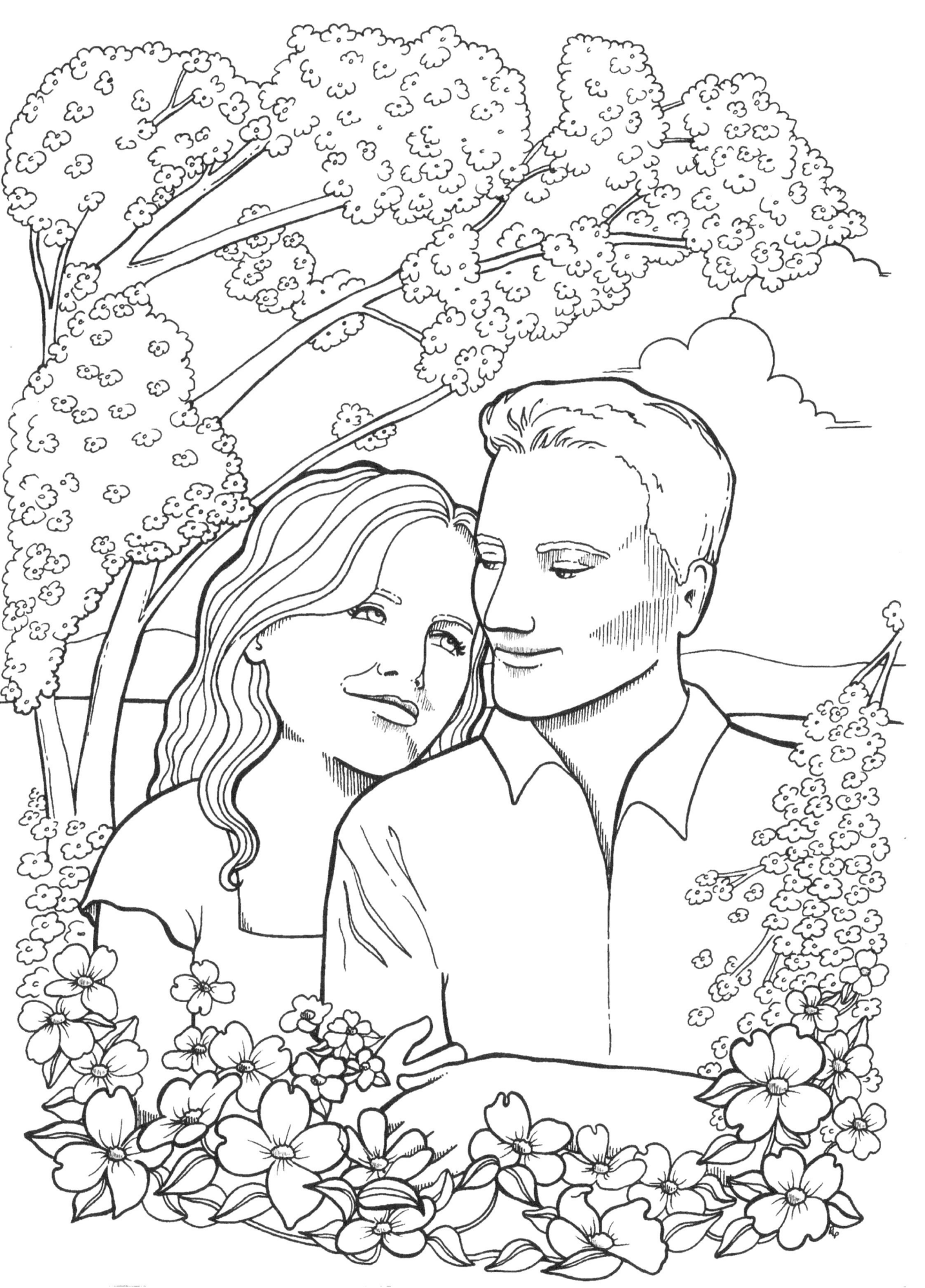

His Love ENDURES forever.

Psalm 136:1

Color Test Page...

www.ingramcontent.com/pod-product-compliance
Lightning Source LLC
Chambersburg PA
CBHW081639220526
45468CB00009B/2499